REMEMBERING THE
GREENS OF GRASMERE

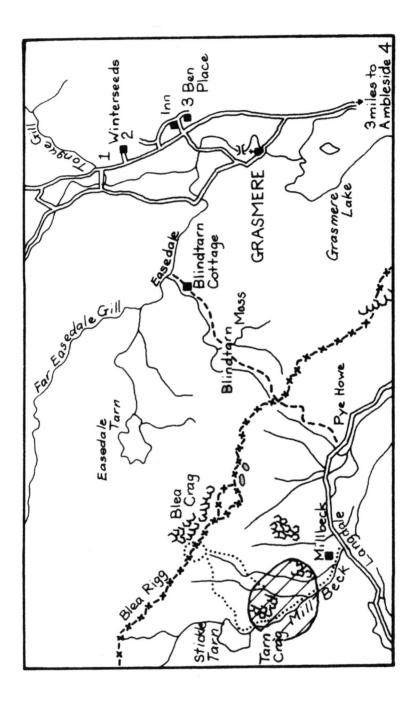

Remembering the

Greens *of* Grasmere

A village bicentenary, March 2008

THE WORDSWORTH TRUST

For Richard Hardisty, whose love of Grasmere is an inspiration

Frontispiece: Map of Grasmere and Langdale showing
the Green family home, Blindtarn Cottage
Published by the Wordsworth Trust
Dove Cottage, Grasmere, Cumbria LA22 9SH
© 2008
Text © the authors, 2008
Photography by Alex Black, Craig Birtles and John Coombe
All rights reserved

We acknowledge the works of Ernest de Selincourt (1936)
and Hilary Clark (1987) in the publication of this text.

ISBN 978 1 905256 33 4

Designed by Craig Birtles
Printed by Titus Wilson, Kendal

MUSEUMS LIBRARIES ARCHIVES
PARTNERSHIP

*Renaissance is about transforming England's regional museums,
making them world-class and fit for the twenty-first century*

MUSEUMS LIBRARIES ARCHIVES
NORTH WEST

CONTENTS

*Interspersed throughout the book are works by the children of
Grasmere School made in response to the Green Tragedy*

A FAMILY TREE

─── *George Green* ───

By Jennet, (née Mackereth)	By Sarah, (née Wilson)
Margaret *b.* 1766	Mary *b.* 1793
George *b.* 1768 *d.* 1786	Sarah *b.* 1795
Betty *b.* 1771	Jane *b.* 1796
Aggy *b.* 1775 *d.* 1842	George (2) *b.* 1798
James *b.* 1777 *d.* 1851	John *b.* 1800
	William *b.* 1804
	Thomas *b.* 1805
	Hannah *b.* 1807

CHILDREN OF SARAH WILSON (GREEN) BEFORE HER MARRIAGE

Son and daughter in service in Langdale in 1808, and visited just before the death of their mother.

b. = date of baptism, birth dates not available

INTRODUCTION

Jeff Cowton

On 19 March 1808, severe wintry weather prevented George and Sarah Green returning from Langdale to their Easedale home at Blindtarn Cottage. Six of their eight children, aged from one to eleven, were waiting for them at home. After two nights alone, one of the children went for help and sparked a search of the fells by the local men. Two days later, the parents' bodies were recovered; they were buried in Grasmere churchyard within a week of their deaths. The Grasmere community immediately set about raising a fund for the care and education of the orphans, ensuring that the children were raised by families within the community into which they had been born.

In contrast, 19 March 2008 was a beautiful, calm day. Forty people walked to Blindtarn Cottage: much had changed inside, but those present felt a sense of history as they tried to imagine the six children left alone in this remote location. The return route included Kittycrag Cottage (a former home of the Greens) and Lancrigg woods with its Wordsworthian associations.

Later that day, readings by descendants of the Greens and Grasmere residents (Sarah Jones, James Thompson, Alan Read, Joy Magennis and Paul Nelson), as well as performances of music and drama by village school children, took place in St Oswald's Church, Grasmere (Jo Goode, Headteacher of Grasmere School, describes the children's involvement in a later section of this book). After the service, Lesley Jones, who, with her daughter Sarah, is thought to be the only descendant of the Greens still living in the village, laid flowers on the gravestone of George and Sarah Green in the churchyard.

The previous evening, eighty people gathered in the Wordsworth Trust's Jerwood Centre to listen to a talk by Professor Michelle Levy on Dorothy Wordsworth's narrative, held in the Trust's collection, describing the events of 1808 as they unfolded. To continue our evening of talks, Richard Hardisty, a descendant of an established Grasmere family, gave a personal account of the Green tragedy as someone who grew up in the village. It was a very moving contribution that reflected his depth of feeling. His wife Jennifer prepared the flowers for the grave.

Overall, this was a family and village occasion. Many direct descendants of George and Sarah had travelled from as far away as London to remember their forebears, meet contemporary relatives for the first time and contribute information to an ever-growing family tree. Information and stories were shared throughout the two days. James Thompson, another descendant, brought his annotated family Bible including a Green family tree dating from

1800 (James has generously placed the Bible on long-term loan to the Trust so that it can be enjoyed in the village for years to come). During the service, an email message of good wishes from an Australian-based descendant was also read out in church.

I have permission to quote from an email I received from Richard after the event, concerning a conversation between himself and Joy Magennis, one of the readers in church: 'Joy was full of emotion and thanked me in the churchyard. She had been so anxious about reading in church, but so wanting to do it for Grasmere and for her forebears. "I'm so grateful and so pleased to have been a part of it" she said'.

The major historical sources for understanding the tragedy are Dorothy Wordsworth's *Narrative of George and Sarah Green*, and the acc-ounts of moneys raised and spent for the childrens' welfare. These are part of the Wordsworth Trust's Designated collection of manuscripts, books and fine art housed in the Jerwood Centre at Wordsworth's home of Dove Cottage, Grasmere. The narrative, written in May 1808, details the family's background, the events of the tragedy and the community's determined response to it. In all, there are four manuscripts of the narrative in the collection, including the version printed in this book. It was first printed in 1936 by Ernest De Selincourt after which Hilary Clark republished it in 1987. Hilary very kindly gave permission for the Trust to use any materials from her book in its future publications. This is the moment to thank her for her generosity: her volume has been much read in the weeks preparing for these events. Stella Colwell's *Tracing the Family Tree* has been invaluable in compiling the family history. The Trust also owns several drawings by Charlotte Maria Fletcher of Lancrigg from 1892 showing Blindtarn and Kittycrag cottages. Of particular interest, Blindtarn is shown with a large tree by the entrance that was removed as part of modernisation in the 1950s.

It has been wonderful to have the opportunity to work with Grasmere School. Being only five minutes walk away, the children have been frequent visitors to the museum and its collections, and it has been a privilege for us to work with such enquiring and imaginative children and supportive and creative staff. The children soon felt at home, but showed appropriate respect when original artefacts were being researched. Such was their absorption in the Green family and Blindtarn Cottage that they were thrilled when I told them that the museum had a knife and fork that once belonged to the cottage, which were immediately selected for display! This demonstrates how, given appropriate preparation and context, even the lowliest kitchen utensils can take on special meaning. We look forward to working closely with the school again on future projects.

For the Trust, the timing of the commemoration coincided with the end of a two-year series of exhibitions, events and activities focusing on the lives of women and domestic family life over the past two hundred years. Central

to this are the thousands of letters, diaries and sketchbooks by women held in the Jerwood Centre. We have come to see the collection in a new light: Dove Cottage itself has hosted events of music and Lakeland step dancing based on descriptions in letters from the collection; an exhibition of women's letters in the Wordsworth Museum has shown the contrast and similarities in relationships, health and well being between 1800 and the present. Talks held in the Jerwood Centre using the collections have opened up new perspectives to new audiences; activities of bookbinding, knitting and embroidery have given appreciation of past skills held by women of Wordsworth's family and circle. It seems very poignant that the end of this programme should coincide with a commemoration of an event in which the role of women (including Wordsworth's wife Mary) was so crucial, and in which Dorothy Wordsworth's writing is so central to our understanding of it.

<p style="text-align:center">★★★</p>

The commemorative events were organised by Grasmere residents, Green family descendants, Grasmere School, Grasmere Church and the Wordsworth Trust. It is a pleasure and a privilege to be part of this community. It is also a pleasure to acknowledge and to thank the MLA, throught the Renaissance Designation Challenge Fund for their major financial contribution to our work (including printing and distribution of this booklet to every school in Cumbria). I should like to thank the Trustees and Director of the Wordsworth Trust for giving us the opportunity to develop this programme, and to thank colleagues for fundraising, administering and promoting the events programme. Importantly, I would like to congratulate my colleagues in the curatorial team at the Trust for their achievement, knowledge and skill in bringing alive aspects of the collection hitherto unexplored for the benefit of so many people; their enthusiasm and creativity served as the engine house that made it happen. Those who have contributed to and prepared this book have created a very fine and fitting memorial. Thanks must also be given to those friends, new and old, who we have come to know, and who have supported us throughout. This includes the many people who organised and ran events as part of the programme. I think, in the words of Dorothy Wordsworth: '. . . I am happy to tell you that others, at the same time, were employing their thoughts in like manner; and our united efforts have been even more successful than we had dared to hope' (Dorothy Wordsworth, *Narrative of George and Sarah Green*).

TRADITIONAL SONG

Written by children from Grasmere School

Mist like a kestrel hovering
Snow brings fear of death
Swirling creeping clouds are tumbling
Lost on the fells
The mist it creeps, the mist crawls
Bewildering all eyes
Staggering in the blizzard
Lost on the fells

George and Sarah Green lost on the fells
Never to return again

Six lonely children waiting
Anxious for some news
One long night and then another
Waiting for their folk
The wind howling round the roof
Windows creak and moan
Listening desperately for footsteps
Of their mum and dad

George and Sarah Green lost on the fells
Never to return again

SOCIAL HISTORY, MANUSCRIPT REMAINS: THE WORDSWORTHS AND THE GREENS

Michelle Levy

On March 19, 1808, George and Sarah Green, husband and wife, perished in Langdale Fell during a storm, leaving behind eight orphaned children, all under the age of sixteen and six under age eleven, an event which threw 'the whole vale,' in Dorothy Wordsworth's words, into 'the greatest consternation'. Immediately, the Wordsworths were 'employed in laying schemes to prevent the children from falling into the hands of persons who may use them unkindly,' which they regarded as a distinct possibility if the children suffered the usual fate of destitute orphans. Dorothy, Mary and William thus began a concerted letter-writing campaign, including a brief account of the events in their correspondence and soliciting donations by pleading for the hopeless condition of the orphans. Soon thereafter, Dorothy, according to her brother, formed the plan 'to draw up a minute detail of all that she knows concerning the lives and characters of the Husband and Wife, and everything relating to their melancholy end, and its effect upon the Inhabitants of this Vale; a story that will be rich in pleasure and profit'. This lengthier version, *Narrative Concerning George and Sarah Green of the Parish of Grasmere addressed to a Friend*, which survives in four versions held by the Wordsworth Trust, form part of a much larger collection of manuscript remains that detail the Wordsworths' and the wider community's response to the tragedy that befell the Greens.

The success of the Wordsworths' efforts, and the generosty of those to whom they appealed, is immediately apparent upon perusal of the subscription book. By the middle of May more than £300 had been raised, and by September over 300 individual donors had pledged nearly £500. The amount given varied greatly, as we would expect, according to the means of the donor, from the ten guineas given by the Bishop of Llandaff and Lord Muncaster, to mere sixpences made by local laboring people and servants, many of whom could probably ill afford even these small sums. The Wordsworths made no contributions themselves, instead resolving on keeping Sally Green, the second eldest daughter whom they had hired as a nursemaid and had planned to part with at Whitsuntide.

A group of local residents quickly organized to supervise the collection of subscriptions, to administer the funds collected, and to oversee the care of the children. The rector of Grasmere, the Reverend Thomas Jackson, agreed to act as trustee; George Mackereth, the parish clerk, was appointed official collector; and six women, Mrs. Watson (the wife of the Bishop of Llandaff), Mrs. Lloyd (wife of author Charles Lloyd), Mrs. King and Mrs. North, both recent settlers in the neighborhood, Miss Susannah Knot, as well as Mary Wordsworth, were appointed to undertake the daily operation of the trust. The raising of the subscription was to protect the Green children from exploitation, for parish orphans in Grasmere were 'let' to the lowest bidder, and because the provision for their care was so slight (two shillings per week until the age of ten), according to Dorothy it was often the case that 'the least able to provide for them are often the readiest bidders, for the sake of having a little money coming in'. At age ten, once no longer eligible for parish support, the children were 'put out as Parish Apprentices, at best,' according to Dorothy, 'a slavish condition'. The monies raised, by providing for the costs of clothing, schooling, books, and medical expenses, and by supplementing the parish allowance with an additional one shilling per week, meant that the children could be placed with 'respectable families' who took them in, as Dorothy explains, 'less for the sake of profit than from a liking to Children in general.' The Green children could also remain in homes near where they were born and raised, and indeed in close proximity to one another. Five of the children were settled in Grasmere, indeed within a short distance from one another along the Keswick road. Their futures were thus far more secure than the 'parish-boy' Wordsworth describes in his poem 'Michael,' based on the true story of one Robert Bateman, who had been sent to London to find a master with a collection the village had made for him of 'shillings, pence, / And halfpennies' and 'A basket which they fill'd with Pedlar's wares'.

One of the most poignant aspects of Dorothy's *Narrative* is found in her description of the first task that fell to the women in charge of administering the Trust, that of placing the Green children in their new homes. Dorothy represents at once the pathos of the children's separation and dispersal and the promise of comfort they bring to the childless homes in which they are received. Dorothy records how: 'It had been declared with one voice by the people of the Parish, men and women, that the Infant and her Sister Jane [the eldest daughter still at home], were not to be parted'. Jane, age 12, and Hannah, just over a year, were placed with the Watsons, a childless couple who lived at Winterseeds; Mrs. Watson was a relation of George Green's first wife, and John Watson a skilled blacksmith; both were highly respected for their intelligence and compassion. Thomas and William, three and four year-olds, were placed with the Dawsons at Ben Place. The Dawsons were an older couple, whose 20-year old son had recently died and whose other children being grown, the husband, we are told, 'had yielded to [his wife's] desire of

taking these poor Orphans thinking they might divert her brooding thoughts'. The seven-year-old boy John went to live with John Fleming, an older man, 'feeble and paralytic,' who had been friends with George Green and who had, 'from the day that the death of their Parents was known, . . . expressed a wish to have the care of little John'. And the eldest boy, ten-year-old George, was the only one sent from Grasmere, though he went to Ambleside to live with his half-brother James.

Throughout the twenty-odd years of the trust's existence, payments were regularly made to these families for boarding, clothing, schooling, books, and medical expenses. From the surviving manuscript receipts and accounts— preserved at the Wordsworth Trust—we may piece together a vivid portrait of the ongoing care these children received within their adoptive homes. The funds were raised in part 'to give them a little school-learning,' and indeed, all of the children received some school education, a most unlikely occurrence had the parents lived. The funds were also to apprentice the boys and to fit the girls out for service, and, from what is known, all of the children were found good situations and made prosperous marriages. Indeed, by 1822, payments from the trust had practically ceased, indicating that the older children had become self-sufficient. It was six years later, when Hannah came of age in 1828, that the distribution of the remaining funds and the winding up of the trust could be contemplated. Indeed, so well had the money been invested, and so scrupulous had the women been in superintending the funds, that the final balance was some £36 *more* than the original total raised. That is, of the original £500 raised, some £536 remained to be divided amongst the eight children. On May 25, 1829, all of the children but one, and many of the original trust administrators, met at Rydal Mount to disperse £60 to each of the Green children, with £20 paid to their half-brother James, who had maintained George.

<p style="text-align:center">★ ★ ★</p>

In the *Narrative*, Dorothy expresses her satisfaction at what her family and the wider community had done to respond to the tragedy; at the same time she indulged in gloomy reflections on the extreme deprivations of the Greens while they lived. Dorothy begins the *Narrative* by describing the Greens as the 'poorest in the vale,' and she proceeds to chronicle the depths of their destitution. While a number of facts relating to the extent of the Greens' poverty are brought to light *after* the deaths of Sarah and George Green—the villagers discovered in their cottage barely two days worth of food and no money whatsoever, and only three-pence was found on each of their bodies—there were many indications of severe deprivation long before their deaths. It was known, for example, that their land was heavily mortgaged, that they had been forced to sell their horse, that their cow was old and barely gave a quart of

milk a day, that 'they were in the habit of carrying any trifles they could spare out of house or stable to barter for meal or potatoes,' that George Green, aged 65, endeavored to earn money by doing odd jobs for his neighbors, that they rented their land to others for pasture, and that they had been forced to sell peat in the summer, dug, as Dorothy explains, 'out of their own heart's heart, their Land'. As Dorothy puts it in a note: 'If I were to enumerate all the things that were wanting even to the ordinary supply of a *poor* house, what a long list it would be!' The only complaint lodged by the community against the Greens, as reported by Dorothy, is that they were 'too stiff,' that is, too unwilling to receive favors though this may have lessened their burdens. But Dorothy quickly dismisses this criticism by asking, 'Without this pride what could have supported them?' for it was their independence that preserved them through 'the many hardships and privations of extreme poverty'.

The Greens' independence derived largely from their customary property rights, which tied them not only to their ancestors but also to the land itself, which for them was a 'salutary passion'. The Greens held rights to three parcels of land in Easedale — at Blindtarn Gill, and enclosures at Kittycrag and Bremer. George Green inherited these properties from his father, George Green, Sr., in 1787. He was deemed an owner of these lands because the rent he paid for them was a token amount; for the Blindtarn property, the yearly customary rent was 3 shillings 7 pence, and he paid only 5 ½ pence the other two. As small landowners, the Greens were taxed on their property (in 1808 the estate paid 2 shillings 7 pence) but were ineligible for any form of parish support. That the Greens, who paid just over 5 shillings yearly for the rent and taxes on their three parcels of land, had sunk below subsistence and appear to have been on the brink of starvation, establishes the grave socio-economic problem that the Wordsworths depicted over and over again in their writing. For it was the laboring poor, including the small landowners like the Greens who, despite their best efforts, could not support their families, that posed the most intractable difficulties — even beyond those facing poor orphans. George Green's will, held in the Lancashire Record Office, acknowledges the severity of his family's predicament by directing that his main property at Blindtarn be sold with the proceeds made over to Sarah, a last resort made necessary by there being no other assets and no other means of providing for his widow and children. As it was, the land was so heavily mortgaged that nothing remained after its sale.

Like many of William's poems, Dorothy's *Narrative* implies that little could be done to save families like the Greens. Men who could not support their families by working on the family land populate William's poetic landscape— there is Margaret's husband in *The Excursion*, Luke in 'Michael,' and Leonard in 'The Brothers'. In these poems, the men are forced to leave their farms to earn money; they usually depart for the cities, always with dismal results. Wordsworth describes the men he depicts in these poems as examples of a

'spirit' and a 'class of men' that he felt to be 'rapidly disappearing,' lamenting that 'no greater curse could befall a land' than this loss. The one ambivalent 'consolation' Dorothy finds in the deaths of George and Sarah Green is that at least it preserved them 'from that dependence which they dreaded,' for had they lived they would almost certainly have been forced to sell their land, and thereafter 'the happy chearfulness of George and Sarah Green might have forsaken them, and their latter days have been tedious and melancholy'. That Dorothy entertains the notion that death is preferable to dependence suggests just how demeaning that dependence would have been, and also how hopeless she was that their kind might be saved from extinction.

Edited version of a paper read at the evening event in the Jerwood Centre, Dove Cottage, 18 March 2008

DIARY OF WILLIAM GREEN, AGED 4, 19 MARCH 1808

Mum and Dad have not returned
from the sale. The baby is asleep
on the floor near the fire and
I'm putting my back into washing
the plates. The blizzard is
getting so bad that I don't think
Mum and Dad can have set off back.
I bet they stopped in the barn
where the sale is. Thomas and I
hope Mum and Dad will be back in
the morning. Jane and all of us
are feeling so sad and upset,
and Hannah needs feeding.

Fictional account by Matthew Powell
of Easedale, aged 10

A NARRATIVE CONCERNING GEORGE & SARAH GREEN OF THE PARISH OF GRASMERE ADDRESSED TO A FRIEND

Dorothy Wordsworth

You remember a single Cottage at the foot of Blentern Gill – it is the only dwelling on the western side of the upper reaches of the Vale of Easedale, and close under the mountain; a little stream runs over rocks and stones beside the garden wall, after tumbling down the crags: I am sure you recollect the spot: if not, you remember George and Sarah Green who dwelt there. They left their home to go to Langdale on the afternoon of Saturday the 19th of March last: it was a very cold day with snow showers. They fixed upon that time for going because there was to be a Sale in Langdale; not that they wanted to make purchases; but to mingle a little amusement with the main object of the Woman's journey at least, which was to see her Daughter who was in service there, and to settle with her Mistress about her continuing in her place.

Accordingly, after having spent a few hours at the Sale, they went to the house where the young Woman lived, drank tea, and set off homewards at about five o'clock, intending to cross over the Fells, and drop down just upon their own Cottage; and they were seen nearly at the top of the hill in their direct course, by some Persons in Langdale, but were never more seen alive. It is supposed that soon afterwards they must have been bewildered by a mist, otherwise they might almost have reached their own Cottage at the bottom of the hill on the opposite side before daylight was entirely gone. They had left a Daughter at home, eleven years of age, with the care of five other Children younger than herself, the youngest an Infant at the breast; and they, poor Things! sate up till eleven o'clock expecting their Parents: they then went to bed thinking they stayed all night in Langdale because of the weather. All next day they continued to expect them, and again went to bed as before; and at noon on Monday one of the Boys went to the nearest house to borrow a Cloak, and, on being asked for what purpose, he replied that his Sister was going to Langdale, as he expressed it, 'to lait their Folk' meaning to seek their Father and Mother, who had not come home again, as they had expected them, on Saturday. The Man of the house started up immediately, saying that 'they were lost!' – he spread the alarm through the neighbourhood, and many Men went out upon the hills to search; but in vain: no

traces of them could be found; nor any tidings heard, except what I have mentioned, and that a shepherd who had been upon the Mountains on Sunday morning had observed indistinct foot-marks of two Persons who had walked close together. Those foot-marks were now covered with fresh snow: the spot where they had been seen was at the top of Blea Crag above Easedale Tarn, that very spot where I myself had sate down six years ago, unable to see a yard before me, or to go a step further over the Crags. I had left W. at Stickell Tarn. A mist came on after I had parted with him, and I wandered long, not knowing whither. When at last the mist cleared away I found myself at the edge of the Precipice, and trembled at the Gulph below, which appeared immeasurable. Happily I had some hours of daylight before me, and after a laborious walk I arrived at home in the evening. The neighbourhood of this Precipice had been searched above and below, wherever foot could come; yet, recollecting my own dreadful situation, I could not help believing that George and Sarah Green were lying some-where thereabouts. On Tuesday as long as daylight lasted the search was continued. It was like a sabbath in the Vale: for all the Men who were able to climb the heights had left their usual work, nor returned to it till the Bodies of the unfortunate Pair were found, which was on Wednesday afternoon. The Woman was first discovered upon some rough ground just above the mountain enclosures beside Mill Beck, in Langdale, which is the next stream or torrent to that which forms Dungeon Gill Waterfall. Several Persons, the day before, had been within a few yards of the spot where she lay; but her body had then been covered with snow, which was now melted. Her Husband was found at no great distance: he had fallen down a Precipice; and must have perished instantly, for his Skull was much fractured. It is supposed that his Wife had been by his side when he fell, as one of her shoes was left midway on the Bank above the precipice; afterwards (probably having stumbled over a crag) she had rolled many yards down the breast of the hill. Her body was terribly bruised. It is believed that they perished before midnight, their cries or shrieks having been distinctly heard by two Persons in Langdale at about ten o'clock; but they paid little attention to the sounds, thinking they came from some drunken People who had been at the Sale. At that time the wretched Pair had no doubt resigned all hope of reaching their own home, and were attempting to find a shelter any where; and, at the spot where they perished they might have seen lights from the windows of that same house where their cries were actually heard.

Soon after the alarm had been spread on Monday after-noon (and from that moment all were convinced of the truth; for it was well known that if the Mother had been alive she would have returned to her sucking Babe) two or three Women, Friends of the Family (Neighbours they call themselves; but they live at the opposite side of the dale) went to take care of the poor Children, and they found them in a wretched state – 'all crying together'. They had passed two whole days (from Saturday noon till Monday noon) without seeing any body, waiting patiently and without fear; and when the

word came that their Father and Mother must have died upon the hills it was like a thunder-stroke. In a little time, however, they were somewhat pacified; and food was brought into the house; for their stock was almost exhausted, their Parents being the poorest People in the Vale, though they had a small estate of their own, and a Cow. This morsel of Land, now deeply mortgaged had been in the possession of the Family for many generations, and they were loth to part with it: consequently they had never had any assistance from the Parish. George Green had been twice married. By his former Wife he has left one Son and three Daughters; and by her who died with him four Sons and four Daughters, all under sixteen years of age. They must very soon have parted with their Land if they had lived; for their means were reduced by little and little till scarcely anything but the Land was left. The Cow was grown old; and they had not money to buy another; they had sold their horse; and were in the habit of carrying any trifles they could spare out of house or stable to barter for potatoes or meal. Luxuries they had none. They never made tea, and when the Neighbours went to look after the Children they found nothing in the house but two boilings of potatoes, a very little meal, a little bread, and three or four legs of lean dried mutton. The Cow at that time did not give a quart of milk in the day. You will wonder how they lived at all; and indeed I can scarcely tell you. They used to sell a few peats in the summer, which they dug out of their own hearts' heart, their Land; and the old Man (he was sixty-five years of age) might earn a little money by doing jobs for his neighbours; but it was not known till now (at least by us) how much distressed they must have been: for they were never heard to murmur or complain. See them when you would, both were chearful; and when they went to visit a Friend or to a Sale they were decently dressed. Alas! a love of Sales had always been their failing, being perhaps the only publick meetings in this neighbourhood where social pleasure is to be had without the necessity of expending money, except, indeed, our annual Fair, and on that day I can recollect having more than once seen Sarah Green among the rest with her chearful countenance – two or three little-ones about her; and their youngest Brother or Sister, an Infant, in her arms. These things are now remembered; and the awful event checks all disposition to harsh comments; perhaps formerly it might be said, and with truth, the Woman had better been at home; but who shall assert that this same spirit which led her to come at times among her Neighbours as an equal, seeking like them society and pleasure, that this spirit did not assist greatly in preserving her in chearful independance of mind through the many hardships and privations of extreme poverty? Her Children, though very ragged, were always cleanly, and are as pure and innocent, and in every respect as promising Children as any I ever saw. The three or four latest born, it is true, look as if they had been checked in their growth for want of full nourishment; but none appear unhealthy except the youngest, a fair and beautiful Infant. It looks sickly, but not suffering; there is a heavenly patience in its countenance; and, while it lay asleep in its cradle three days after its

Mother's death, one could not look upon it without fanciful thoughts that the Babe had been sent into this life but to be her Companion, and was ready to follow her in tranquil peace.

It would not be easy to give you an idea of the suspense and trouble in every face before the bodies were found: it seemed as if nothing could be done, nothing else thought of, till the unfortunate Pair were brought again to their own house: - the first question was, 'have you heard anything from the Fells?' On the second evening I asked a young Man, a next-door Neighbour of ours, what he should do tomorrow? 'Why, to be sure, go out again,' he replied, and I believe that though he left a profitable employment (he is by trade a Shoe-maker), he would have persevered daily if the search had continued many days longer, even weeks.

My Sister Mary and I went to visit the Orphans on the Wednesday morning: we found all calm and quiet – two little Boys were playing on the floor – the Infant was asleep; and two of the old Man's up-grown Daughters wept silently while they pursued the business of the house: but several times one of them went out to listen at the door – 'Oh!' said they, 'the worst for us is yet to come! We shall never be at rest till they are brought home; and that will be a dreadful moment.' – Their grief then broke out afresh; and they spoke of a miserable time, above twenty years ago, when their own Mother and Brother died of a malignant fever: nobody would come near them, and their Father was forced himself to lay his Wife in her coffin. 'Surely,' they often repeated, 'this is an afflicted House!' – and indeed in like manner have I since frequently heard it spoken of by Persons less nearly concerned, but who still retain a vivid remembrance of the former affliction. It is, when any unusual event happens, affecting to listen to the fireside talk in our Cottages; you then find how faithfully the inner histories of Families, their lesser and greater cares, their peculiar habits, and ways of life are recorded in the breasts of their Fellow-inhabitants of the Vale; much more faithfully than it is possible that the lives of those, who have moved in higher stations and had numerous Friends in the busy world, can be preserved in remembrance, even when their doings and sufferings have been watched for the express purpose of recording them in written narratives. I heard a Woman, a week ago, describe in as lively a manner the sufferings of George Green's Family, when the former two Funerals went out of the house, as if that trouble had been the present trouble. Among other things she related how Friends and Acquaintances, as is the custom here when any one is sick, used to carry presents; but, instead of going to comfort the Family with their company and conversation, laid their gifts upon a Wall near the house, and watched till they were taken away.

It was, as I have said, upon the Wednesday that we went to visit the Orphans. A few hours after we had left them John Fisher came to tell us that the men were come home with the Dead Bodies. A great shout had been uttered when they were found; but we could not hear it as it was on the Langdale side of the Mountains.

The Pair were buried in one Grave on the Friday after-noon. My Sister and I attended the Funeral. A great number of people of decent and respectable appearance were assembled at the House. I went into the parlour where the two Coffins were placed with the elder of the Mourners sitting beside them: the younger Girls gathered about the kitchen fire, partly amused, perhaps, by the unusual sight of so many persons in their house; the Baby and its Sister Jane(she who had been left by the Mother with the care of the Family) sate on a little stool in the chimney-corner, and, as our Molly said, after having seen them on the Tuesday, 'they looked such an innocent Pair!' The young Nurse appeared to have touches of pride in her important office; for every one praised her for her notable management of the Infant, while they cast tender looks of sorrow on them both. The Child would go to none but her; and while on her knee its countenance was perfectly calm – more than that: I could have fancied it to express even thoughtful resignation.

We went out of doors, and were much moved by the rude and simple objects before us – the noisy stream, the craggy mountain down which the old Man and his Wife had hoped to make their way on that unhappy night – the Little garden, untitled, – with its box-tree and a few peeping flowers! The furniture of the house was decayed and scanty; but there was one oaken Cupboard that was so bright with rubbing that it was plain it had been prized as an ornament and a treasure by the poor Woman then lying in her Coffin.

Before the Bodies were taken up a threepenny loaf of bread was dealt out to each of the Guests: Mary was unwilling to take hers, thinking that the Orphans were in no condition to give away anything; she immediately, however, perceived that she ought to accept of it, and a Woman, who was near us, observed that it was an ancient custom now much disused; but probably, as the Family had lived long in the Vale, and had done the like at funerals formerly, they thought it proper not to drop the custom on this occasion. The funeral procession was very solemn – passing through the solitary valley of Easedale, and, altogether, I never witnessed a more moving scene As is customary here, there was a pause before the Bodies were borne through the Church-yard Gate, while part of a psalm was sung, the men standing with their heads uncovered. In the Church the two Coffins were placed near the Altar, and the whole Family knelt on the floor on each side of the Father's Coffin, leaning over it. The eldest Daughter had been unable to follow with the rest of the Mourners, and we had led her back to the house before she got through the first field; the second fainted by the Graveside; and their Brother stood like a Statue of Despair silent and motionless; the younger Girls sobbed aloud. Many tears were shed by persons who had known little of the Deceased; and all the people who were gathered together appeared to be united in one general feeling of sympathy for the helpless condition of the Orphans. After the Funeral the Family returned to their melancholy home. There was a Sale

of the furniture on the Thursday following; and the next day the house was left empty and silent.

A Lady from Ambleside had fetched the four little Boys on the day of the Funeral, to keep them till it should be settled how they were to be disposed of. I saw them go past our door; they walked up the hill beside the Car in which they had been riding, and were chattering to their new Friend, no doubt well pleased with the fine Carriage. We had been told that she was going to take them and bring them up entirely herself; and my Sister came downstairs with tears of joy in her eyes. 'Aye,' said our Neighbour, Peggy Ashburner, 'that Woman will win Heaven for protecting the Fatherless and Motherless;' and she too wept. Afterwards, however, we were undeceived, and were afraid that the Lady's kindness was ill-judged, that it might unsettle them when they should be taken away from the grand house to a more humble dwelling.

There are eight Children left under sixteen years of age. The eldest, a Girl, is in service, the second has lived with us more than half a year, and we had intended parting with her at Whitsuntide; but when we heard of the loss of her Parents, we determined to keep her till she also is fit for service. The eldest, and only remaining Son of George Green by his first Wife, will maintain one of the Boys and bring him up to his own trade; so that there remain five to be provided for by the Parish; for, after the father's estate is sold and the Mortgage paid off, little or nothing will remain for his Family.

It is the custom at Grasmere, and I believe in many other places, to let, as they call it, those Children who depend wholly upon the Parish, to the lowest Bidder, that is, to board them out with those Persons who will take them at the cheapest rate; and such as are the least able to provide for them properly are often the readiest Bidders, for the sake of having a little money coming in, though in fact the profit can be but very small.' But they feel that they get something when the money comes, and do not feel exactly what they expend for the Children because they are fed out of the common stock. At ten years of age they are removed from their boarding-houses, and generally put out as Parish Apprentices, at best a slavish condition; but sometimes they are hardly used, and sometimes all moral and religious instruction is utterly neglected. I speak from observation: for (I am sorry to say it) we have daily before our eyes an example of such neglect in the Apprentice of one of our near Neighbours. From the age of seven or eight till he was eleven or twelve years old the poor Boy was employed in nursing his Mistress's numerous Children, and following them up and down the lanes. Sunday was no holiday for him; he was not, like others, dressed clean on that day; and he never went to Church. I recollect, when I first came to live in this Country, a little more than eight years ago, observing his vacant way of roaming about. I observed that there was an appearance of natural quickness with much good temper in his countenance; but he looked wild and untutored. It was the face of a Child who had none to love him, and knew not in his heart what love was. He is now sixteen years old and a strong handsome-featured Boy;

but, though still the same traces of natural sense and good-temper appear, his countenance expresses almost savage ignorance with bold vice. To this day he does not know a letter in a book; nor can he say his prayers; (as Peggy Ashburner expressed it strongly in speaking of him to Sara) 'That poor Lad, if aught were to happen to him, cannot bid God bless him!' His Master has a couple of crazy horses, and he now employs him in carrying slates to the next market-town, and, young as he is, he has often come home intoxicated. Sometimes no doubt the liquor is given to him, but he has more than once been detected in dishonest practices, probably having been tempted to them by his desire of obtaining liquor. I hope and believe that it does not often happen in this neighbourhood that Parish Apprentices are so grossly neglected as this Boy has been; and I need not give you my reasons for thinking that there is not another Family in Grasmere who would have done the like: nor could it have been so bad even in this instance if the Boy had not come from a distant place, and consequently the Parish Officers are not in the way of seeing how he goes on; and I am afraid that in such cases they seldom take the trouble of making inquiries.

You will not wonder, after what I have said, that we have been anxious to preserve these Orphans whom we saw so uncorrupted from the possibility of being brought up in such a manner, especially as there is no likelihood that they would all have been quartered in their native Vale. From the moment we heard that their Parents were lost we anxiously framed plans for raising a sum of money for the purpose of assisting the Parish in placing them with respectable Families; and to give them a little school-learning; and I am happy to tell you that others, at the same time, were employing their thoughts in like manner; and our united efforts have been even more successful than we had dared to hope.

It was a month yesterday since the sad event happened, and the Children are settled in their several homes, and all are in the Vale of Grasmere except the eldest Boy, George, who is with his Brother at Ambleside. A Subscription has been made for the purpose of adding a little to the weekly allowance of the Parish, and to send them to School, to apprentice the Boys, and to fit the Girls out for service; and if there be any surplus, it is to be dealt out among them as they shall prove deserving, or according to their several needs to set them forward in Life. It was very pleasing to observe how much all, both rich and poor, from the very first appeared to be interested for the Orphans; and the Subscription-book, which we have seen this evening, is equally creditable to all ranks. With five guineas, ten guineas, three guineas, is intermingled a long list of shillings and sixpences, and even one threepence – many of these smaller contributions from labouring people and Servants. A Committee of six of the neighbouring Ladies has been appointed to overlook the Children and manage the funds. They had a meeting, and it was agreed that Mrs. Wordsworth and Mrs. King should engage with two Families who were willing to take three of the Orphans, less for the sake of profit than from a lik-

ing to Children in general, and from a wish to see these children well taken care of, who had been left in circumstances of such peculiar distress. Another Lady had commission to conclude an engagement with a third Person who was willing to have the charge of the Infant and her Sister Jane. This Lady, I am sorry to say, was galled that the whole concern had not been entrusted to her guidance, and had before (without any authority) herself (though only recently come into the Country and having no connection with Grasmere) engaged to place all the Children with an old Woman in indigent circumstances, who was totally incapable of the charge. I will not blemish a narrative of events so moving, which have brought forward so many kind and good feelings, by entering into the cabals and heart-burnings of Mrs ~ It is enough to say that Miss Knott, the Lady who has had the four Boys under her protection since the day of their Parents' Funeral, came to conduct the three youngest and their two Sisters to their new homes, attended by Mrs ~ . George, the eldest, had been left at his Brother's house, where he is to remain. The Ladies called at our door in their way; and I was deputed to attend them in my Sister's place, John being very ill, and his Mother unable to leave him. I had the satisfaction of seeing all the five Children hospitably welcomed. It had been declared with one voice by the people of the Parish, men and women, that the Infant and her Sister Jane should not be parted. The Woman who was to have the care of these two, was from home, and had requested a Neighbour to be in the way to receive them when they should come. She has engaged to instruct Jane in sewing and reading, being, according to the phrase in this Country 'a fine Scholar'. Her Husband is living; but she has never had any Children of her own. They are in good circumstances having a small estate of their own, and her husband is a remarkably ingenious and clever Man, a Blacksmith by trade; and she appears to be a kind-hearted Woman, which is shown by her motives for taking these poor Children. She said to my Sister with great simplicity and earnestness: 'I should not have done it if we had not been such near relations, for my Uncle George's (namely the late George Green's) first Wife and my Husband's Mother were own Sisters ,' from which odd instance of relationship you may judge how closely the bonds of family connection are held together in these retired vallies. Jane and her Sister took possession of their new abode with the most perfect composure; Jane went directly to the fireside, and seated herself with the Babe on her knee: it continues to call out 'Mam!' and 'Dad!' but seems not to fret for the loss of either: she has already transferred all her affections to her Sister, and will not leave her for a moment to go to anyone else. This same little Girl, Jane, had been noticed by my Brother and Sister some months ago, when they chanced to meet her in Easedale; at first not knowing who she was. They were struck, at a distance, with her beautiful figure and her dress, as she was tripping over the wooden bridge at the entrance of the Valley; and, when she drew nearer, the sweetness of her countenance, her blooming cheeks, her modest, wild and artless appearance quite enchanted them. My Brother could talk of nothing

else when he came home, and he minutely described her dress, a pink petti-coat peeping under a long dark blue Cloak, which was on one side gracefully elbowed out, or distended as with a blast of wind by her carrying a basket on her arm; and a pink bonnet tyed with a blue ribband, the lively colours har-monizing most happily with her blooming complexion. Part of this dress had probably been made up of her elder Sister's cast-off cloaths, for they were accustomed to give to their Father's Family whatever they could spare; often, I believe, more than they could well afford. Little did my Brother at that time think that she was so soon to be called to such important duties; and as little that such a creature was capable of so much: for this was the Child who was left by her Parents at the head of the helpless Family, and was as a Mother to her Brothers and Sisters when they were fatherless and motherless, not knowing of their loss. Her conduct at that time has been the admiration of every body. She had nursed the Baby, and, without confusion or trouble, pro-vided for the other Children who could run about: all were kept quiet – even the Infant that was robbed of its Mother's breast. She had conducted other matters with perfect regularity, had milked the Cow at night and morning, wound up the clock, and taken care that the fire should not go out, a matter of importance in that house so far from any other, a tinder-box being a con-venience which they did not possess. This little Girl I saw, as I have told you, take her place in her new home with entire composure: I know not indeed how to find a word sufficiently strong to express what I mean: it was a calm-ness amounting to dignity, which gave to every motion a perfect grace.

We went next with two Boys in petticoats to a neat Farm house: the Man and his Wife came down the lane a hundred yards to meet us, and would have taken the Children by the hand with almost parental kindness; but they clung to Miss Knott, the Lady who had fetched them from their Father's Cottage on the day of the Funeral, and had treated them tenderly ever since. The younger sate upon her lap while we remained in the house, and his Brother leaned against me: they continued silent; but I felt some minutes before our departure, by the workings of his breast, that the elder Boy was struggling with grief at the thought of parting with his old Friend. I looked at him and perceived that his eyes were full of tears: the younger Child, with less fore-sight, continued calm till the last moment, when both burst into an agony of grief. We have since heard that a slice of bread and butter quieted their distress: no doubt the good Woman's kind looks, though she gave to the bread and butter the merit of consoling them, had far more effect. She is by nature loving to Children, mild and tender – inclining to melancholy, which has grown upon her since the sudden Death of a Son, twenty years of age, who was not only the pride of his Father's House, but of the whole Vale. She has other Children, but they are scattered abroad, except one Daughter, who is only occasionally with her, so that she has of late spent many hours of the day in solitude; and the Husband yielded to her desire of taking these poor Orphans, thinking they might divert her brooding thoughts.

She has begun to teach them to read; and they have already won the hearts of the rest of the Family by their docility, and quiet affectionate dispositions; and my Sister thought, when she was at the house a few days ago, that she perceived more chearfulness in the kind Woman's manners than she had observed in her for a long time. They, poor Things! are perfectly contented; one of them was overheard saying to the other, while they were at play together, 'My Daddy and Mammy's dead, but we will never go away frae this House.'

We next went with the last remaining one of our charge, a Boy seven years old: his sorrow gathered while we were in the chaise at the apprehension of parting from his Friend: he repeated more than once, however, that he was glad to go to the house whither we were taking him; and Miss Knott, turning to me, said he told her he should like to live with John Fleming (that was the Man's name) for he had been kind to his Father and Mother, and had given them two sheep last year. She also related what seemed to me a remarkable proof of the Child's sensibility. There had been some intention of fixing him at another place, and he was uneasy at the thought of going thither, because, as he said, the Master of the House had had a quarrel with his Father. It appears that George Green and John Fleming had had a particular regard for each other; he was the Godfather of his Friend's Daughter Jane, to whom he says he will give a fleece of wool every year to spin for her own stockings and, from the day that the death of their Parents was known, he expressed a wish to have the care of little John. The manner in which he greeted the Boy, who could not utter a word for weeping, corresponded with this; he took hold of him and patted his head as lovingly as if he had been his Grandfather, saying, 'Never fear mun! thou shalt go upon the hills after the sheep; thou kens my sheep!' then addressing himself to us he went on – 'This little Lad and his Brothers and Sisters used always to come to our clippings, and they were the quietest Bairns that ever I saw, we never had any disturbance among them.' Meanwhile poor John did not cease crying, and continued to weep as long as we remained in the house; but we have since seen him as happy and contented as plenty of food and kindness could make any Child. His Master is feeble and paralytic, but he spends most of his time out of doors, looking about his own fields or following the sheep. In these walks he had formerly no Companion but his Dog and his Staff: now, at night and morning, before and after school hours, the Boy goes with him – I saw them last night on their return homewards; little John was running here and there as sportive as a mountain lamb; for the Child may wander at will after his own fancies, and yet be a faithful attendant upon his Master's course; for he creeps at a slow pace, with tottering steps. Much as the old Man delights in his new charge, his Housekeeper appears to have little less pleasure in him: I found her last night knitting stockings for him out of yarn spun from the Master's fleeces, which is a gratuitous kindness, their allowance being half a crown weekly for board and lodging. I said to her that I hoped the Boy was dutiful to her; and she replied that there was no need to give him correction, for he did nothing

amiss, and was always peaceable, – and happy too; and she mentioned some little circumstances which proved that she had watched him feelingly; among the rest, that on Saturday, his weekly holiday, he had gone with her and her Master to a mountain enclosure near Blentern Gill where they had some sheep; they passed by his Father's door, and the Child said to her (looking about, I suppose, in one of the Fields which had belonged to his Parents) 'My Mother's Ewe has got a fine Lamb.' The Woman watched his countenance, as she told us, and could not perceive that he had any painful thoughts, but was pleased to see the new-dropped Lamb and his Mother's Ewe.

The Ladies returned to Ambleside after we left John Fleming's house. Mrs ~ , it hurts me to say it, in her way to our door where we parted, appeared sullen and dissatisfied that she had not had the whole management of the concern; but Miss Knott, who has a true interest in the Children's well-doing, expressed great pleasure in what she had observed of the people who had taken charge of them, adding that she trusted the Family would prosper, for she had never seen or even heard of any set of Children that were so amiable as the four who had been under her roof: they were playful but not quarrel-some; and, though with hundreds of objects around them that were perfectly new and strange, they never had done any mischief, hardly had need of a caution! The contentedness with which they have taken to their new homes proves that no wayward desires had been raised in them by the luxuries among which they had lived for the last three weeks; and we have been truly happy to perceive that our fears that this might happen were ill-grounded.

Not only the ladies of the Committee (except the one I have mentioned) but all the Persons in Grasmere with whom I have conversed, approve entire-ly of the several situations in which the Orphans have been placed. Perhaps the irregular interference of Mrs ~ may have called forth a few unbecom-ing expressions of resentment from some of the Inhabitants of the Vale; but I must say that the general feelings have been purely kind and benevolent, arising from compassion for the forlorn condition of the Orphans and from a respectful regard for the memory of their Parents who have left in them a living example of their own virtuous conduct.

I am almost afraid that you may have thought my account of the charac-ters of the Children but a Romance, a dream of fanciful feeling proceeding in great measure from pity, pity producing love; yet I hope that the few facts which I have mentioned concerning them will partly illustrate what I have said. You will conclude with me that if the Parents had not shown an example of honesty, good temper, and good manners, these happy effects could not have followed; but I believe that the operation of their example was greatly aided by the peculiar situation of themselves and their Children. They lived in a lonely house where they seldom saw any body. These Children had no Play-fellows but their own Brothers and Sisters; and wayward inclinations or uneasy longings, where there was no choice of food or toys, no luxuries to contend for, could scarcely exist, they seeing nothing of such feelings in their

Parents. There was no irregular variety in the earlier part of their infancy and childhood, and when they were old enough to be trusted from home they rarely went further than their own fields, except to go on errands; so that even then they would be governed by the sense of having a duty to perform. No doubt many Families are brought up in equal solitude and under the same privations, and we see no such consequences; and I am well aware that these causes have often a baneful effect if the Parents themselves be vicious; but such very poor People as in their situation most resemble these are generally in a state of dependence; and the chain which holds them back from dishonesty or any disgraceful conduct is by no means so strong. While George and Sarah Green held possession of the little estate inherited from their Forefathers they were in a superior station; and thus elevated in their own esteem they were kept secure from any temptation to unworthiness. The love of their few fields and their ancient home was a salutary passion, and no doubt something of this must have spread itself to the Children. The Parents' cares and their chief employments were centred there; and as soon as the children could run about even the youngest could take part in them, while the elder would do this with a depth of interest which cannot be felt, even in rural life, where people are only transitory occupants of the soil on which they live. I need not remind you how much more such a situation as I have described is favourable to innocent and virtuous habits and feelings than that of those Cottagers who live in solitude and poverty without any out-of-doors employment. It is pleasant to me here to recollect how I have seen these very Children (with no Overlooker except when it was necessary for the elder to overlook the younger) busied in turning the peats which their Father had dug out of the field near their own house, and bearing away those which were dry (in burthens of three or four) upon their shoulders. In this way the Family were bound together by the same cares and exertions; and already one of them has proved that she maintained this spirit after she had quitted her Father's Roof. The eldest, Mary, when only fourteen years of age, spared a portion of her year's wages to assist them in paying for the Funeral of her Grandfather. She is a Girl of strong sense, and there is a thought-fulness and propriety in her manners which I have seldom seen in one so young; this with great appearance of sensibility which shewed itself at the time of her Parents' death, and since, in her anxiety for her Brothers and Sisters. Much, indeed, as I have said of the moral causes tending to produce that submissive, gentle, affectionate, and I may add useful character in these Children, I have omitted to speak of the foundation of all, their own natural dispositions, or rather their constitutional temperament of mind and body. I am convinced from observation that there is in the whole Family a peculiar tenderness of Nature; perhaps inherited from their Father, whom I have several times heard speak of his own Family in a manner that shewed an uncommonly feeling heart; once especially, two or three years ago, when his Boy George had scalded himself and was lying dangerously ill, we met him in Easedale, and he

detained us a full quarter of an hour while he talked of the Child's sufferings and his surpassing patience. I well remember the poor Father's words – 'He never utters a groan – never so much as says Oh Dear! but when he sees us grieved for him encourages us and often says: 'Never fear, I warrant you I shall get better again.' These circumstances and many more which I do not so distinctly recollect the old Man repeated with tears streaming down his cheeks; yet we often saw a smile of pride in his face while he spoke of the Boy's fortitude and undaunted courage.

I have said that George Green had been twice married, and that his Son and Daughters by his first Wife are in a respectable condition of life; but he had not only brought up thus far his own large Family; but also two Children, a Son and a Daughter, whom his Wife had borne before marriage. He received eighteen pence weekly towards the maintainance of each, and brought them up as his own Children. I do not know what Sarah Green's general conduct before marriage may have been further than that she was a young Woman when these Children were born. She had been a Parish Apprentice, and there-fore, probably, a neglected Child, and, having had the merit of conquering her failings, she for that cause may perhaps be entitled to a higher praise than would have been her due if she had never fallen. Her conduct as a Wife and a Mother was irreproachable.

Though she could not read herself, she had taught all her Children, even to the Youngest but one, to say their prayers, and had encouraged in them a love and respect for learning; the elder could read a little though none of them had been at school more than a single month in the course of the last summer, except Sally whose schooling was paid for by a lady in whose house she had been a short time. Since their Parents' death two of the Boys have gone regularly to school; and George, the eldest, takes particular delight in his book. The little fellow used to lie down upon the carpet in Miss Knott's parlour poring over the 'Reading-made-Easy' by firelight, and would try to spell words out of his own head.

The Neighbours say that George and Sarah Green had but one fault; they were rather 'too stiff', unwilling to receive favours, but the 'keenest payers', always in a hurry to pay when they had money, and for this reason those who knew them best were willing to lend them a little money to help them out of a difficulty, yet very lately they had sent to the shop for a loaf of bread, and because the Child went without ready money the Shopkeeper refused to let them have the bread. We in our connection with them have had one oppor-tunity of remarking (alas! we gained our knowledge since their death) how chearfully they submitted to a harsh necessity, and how faithful they were to their word. Our little Sally wanted two shifts: we sent to desire her Mother to procure them; the Father went the very next day to Ambleside to buy the cloth and promised to pay for it in three weeks. The shifts were sent to Sally with-out a word of the difficulty of procuring them, or anything like a complaint. After her Parent's death we were very sorry (knowing now so much of their

extreme poverty) that we had required this of them, and on asking whether the cloth was paid for (intending to discharge that debt) we were told by one of the Daughters that she had been to the Shop purposely to make the enquiry, and found that, two or three days before the time promised, her Father had himself gone to pay the money. Probably if they had lived a week longer they must have carried some article of furniture out to barter for that week's provisions. I have mentioned how very little food there was in the house at that time – there was no money – not even a single half-penny! The pair had each three-pence in their pockets when they were found upon the mountains. With this eagerness to discharge their debts their unwillingness to receive favours was so great that the Neighbours called it pride, or as I have said 'stiffness'. Without this pride what could have supported them? Their chearful hearts would probably have sunk, and even their honesty might have slipped from them. The other day I was with Mary Cowperthwaite, the Widow of one of our Statesmen; she began to talk of George and Sarah Green who, she said, 'had made a hard struggle; but they might have done better if they had not had quite so high a spirit.' She then told me that she had called at their house last Summer to look after some cattle that she had put upon George Green's land. Sarah brought out a phial containing a little gin, poured out a glass of it, and insisted that her visitor should drink, saying, 'I should not have had it to offer you if it had not been for that little thing,' pointing to the Cradle, 'it has been badly in its bowels, and they told me that a little common gin would mend it.' Mrs. Cowperthwaite took the gin much against her mind, on condition that Sarah Green should drink tea with her the next Sunday, which she promised to do, and Mary Cowperthwaite told her that she would have a bundle of old cloaths ready for her to take home with her; however she did not go on the Sunday afternoon; and Mrs. Cowperthwaite says that she believes that the fear of receiving this gift had prevented her; for she had never seen her at her house afterwards, though the promise was made many months before her Death. It is plain that the poor Woman had no secret cause of offence against her who would have been her benefactress, for on the day on which she died she followed Mrs Cowperthwaite's Son at the Sale with-ersoever he turned, urging him to request his Mother to take her Daughter Mary as a Servant, she being then in service at a publick House, a situation which she did not altogether approve of.

Within the last few days of Sarah Green's life her thoughts had been very much occupied with her Children. On the day before she died she went to Ambleside with butter to sell, and talked with our neighbour, John Fisher, about her Daughter Sally, and said she should 'think of him', that is, be grate-ful to him as long as she lived for having been the means of placing Sally at our house, regretted that we could not keep her longer; but, in her chearful way, ended with 'we must do as well as we can'. On her road home she fell into company with another Person, and talked fondly of her Infant who, she said, was 'the quietest creature in the world'. You will remember that the

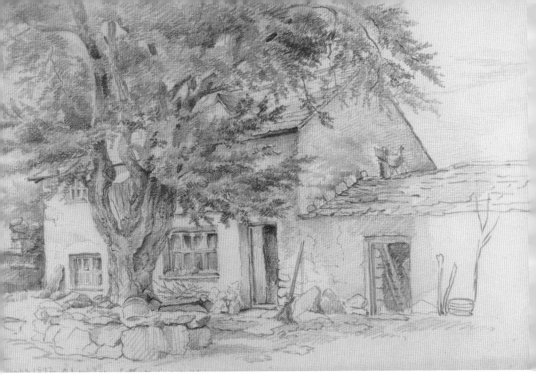

Blindtarn Cottage, Grasmere *by Charlotte Maria Fletcher,*
c. 1892 (from the Wordsworth Trust's collection)

The descendants of the Green family outside the cottage, 19 March 2008

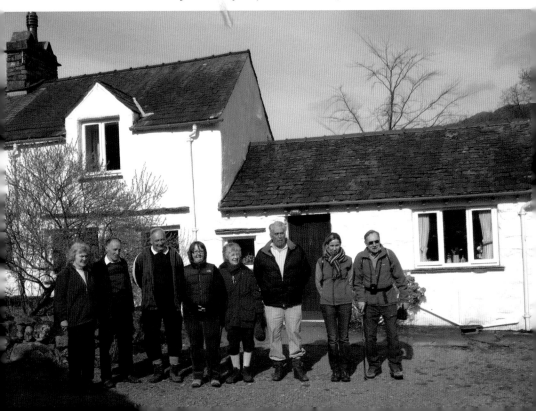

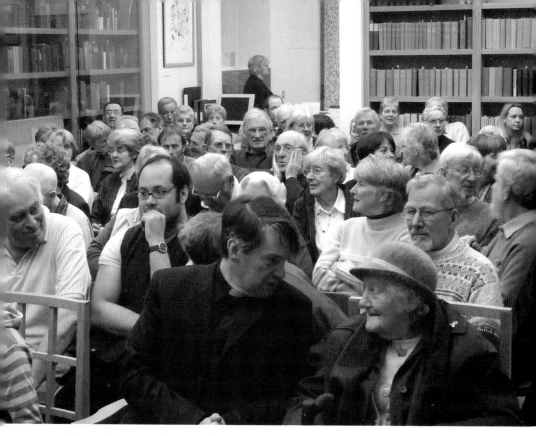

The evening event at the Jerwood Centre, Dove Cottage. Mrs Catherine Dawes, one of Grasmere's 'principal inhabitants', is pictured bottom right talking with the Reverend Cameron Butland

Richard Hardisty and Michelle Levy, contributors to the evening

*Jeff Cowton,
Curator, introduces
the evening*

Descendants discuss the Green family tree with Michelle Levy

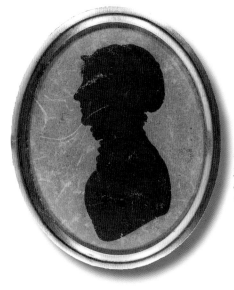

The manuscript of 'A Narrative concerning George & Sarah Green of the Parish of Grasmere addressed to a Friend', part of the Wordsworth Trust's Collections

Dorothy Wordsworth, portrait by an unknown artist, c. 1806, part of the Wordsworth Trust's Collections

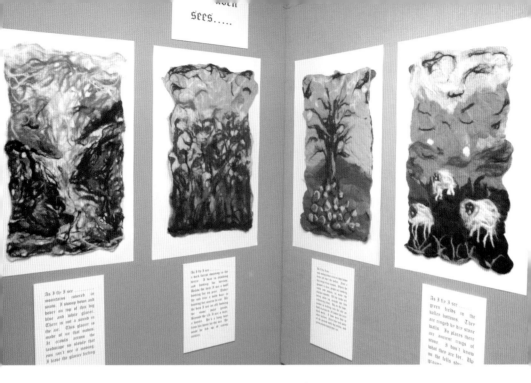

Grasmere School children's exhibition in the Wordsworth Museum and Art Gallery February 2008.
Above: hand-made felt works depicting the history of the Easedale landscape.
Below: a recreation of the interior of Blindtarn Cottage.

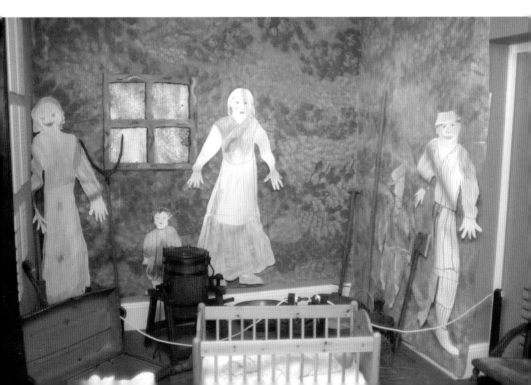

The service of remembering, Grasmere Church, 19 March 2008

Mrs Joy Magennis, resident of Grasmere,
reading from Dorothy Wordsworth's 'Narrative'

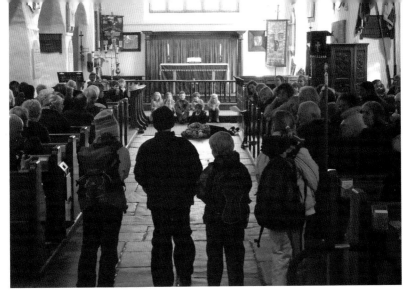

Grasmere School children perform
'The Tragedy of the Greens: What would happen in 2008?'

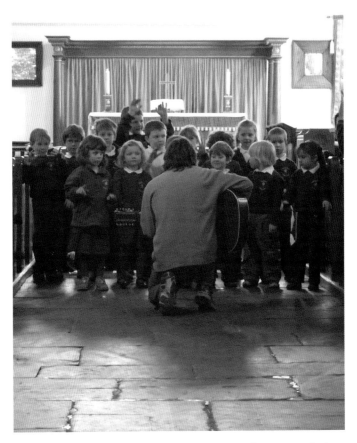

Grasmere School children performing 'A song of stormy weather'

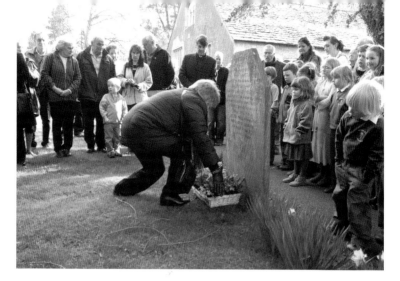

Green family descendants place flowers at the gravestone in
Grasmere Churchyard where George and Sarah Green are remembered

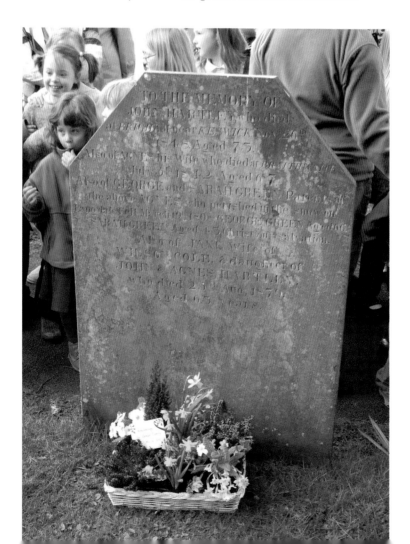

object of her last fatal journey was to look after her Daughter who was a Servant at a house in Langdale; and that while she was at the Sale she took unwearied pains about another (namely her eldest by her husband).

Poor Woman! she is now at rest. I have seen one of her Sons playing beside her grave; and all her Children have taken to their new homes, and are chearful and happy. In the night of her anguish if she could but have had a foresight of the kindness that would be shewn to her Children, what a consolation would it have been! With her many cares and fears for her helpless Family she must at that time have mingled some bitter self-reproaches for her boldness in venturing over the Mountains; for they had asked two of the Inhabitants of the Vale to accompany them, who refused to go by that way on account of the bad weather, and she laughed at them for being cowardly. It is now said that her Husband was always fond of doing things that nobody else liked to venture upon, though he was not strong and had lost one eye by an accident. She was healthy and active, one of the freshest Women of her years that I ever noticed, and walked with an uncommonly vigorous step. She was forty-five years of age at her Death.

Her Husband's Daughters speak of their Mother-in-law with great respect; she always, whenever they went to their Father's house, strove to make it as comfortable to them as she could, and never suffered her own Children to treat them unbecomingly. One of the young Women, who has long been a Servant in respectable Families in the neighbourhood, told us with tears in her eyes, that once, not very long ago, she went to Blentern Gill not intending to stay all night, and when she took up her Cloak to go away her Mother said to her 'What you cannot stop in such a poor House!' The Daughter after this had not the heart to go, and laid aside her Cloak. Another time when the chearful Creature was pressing her to stay longer she said to her 'What, Aggy, to be sure we have no tea, but we have very good tea-leaves.' By the bye, those tea leaves came from our house: one of the little Girls, our own Sally or another, used to come to fetch them – two long miles! I well recollect (it is now five or six years ago) how we were then struck with the pretty simple manners of these little-ones.

I have spoken much of the interest we take in the younger Children of George Green, and I may add that the same constitutional tenderness appears even in a much more marked degree in the elder part of the old Man's Family: we have observed in them many proofs of tender and even delicate sensibility as well as of strong and deep feeling – so much respect for every thing that had belonged to the Deceased – the few cloaths, the furniture and the old Family Dwelling. In no situation of life did I ever witness marks of more profound distress than appeared in them immediately after the death of their Father and Mother; for they called her Mother. The eldest Son, on returning to his own house at Ambleside, after having been at Grasmere on the day when it was first known that they were lost, was unable to lift the latch of his own door, and fainted on the threshold, and might have perished also if

his Wife had not happened to hear him, for it was a bitter cold night.

I may say with the Pedlar in the 'Recluse'

... 'I feel
The story linger in my heart, my memory
Clings to this poor Woman and her Family,'

and I fear I have spun out my narrative to a tedious length. I cannot give you the same feelings that I have of them as neighbours and fellow-inhabitants of this Vale; therefore what is in my mind a full and living picture will be to you but a feeble sketch. You cannot, however, but take part in my earnest prayer that the Children may grow up, as they have begun, in innocence, and that the awful end of their Parents may hereafter be remembered by them in such a manner as to implant in their hearts a reverence and sorrow for them that may purify their thoughts and make them wiser and better.

There is at least this consolation, that the Father and Mother have been preserved by their untimely end from that dependance which they dreaded. The Children are likely to be better instructed in reading and writing, and may acquire knowledge which their Parents' poverty would have kept them out of the way of attaining; and perhaps, after the land had been sold, the happy chearfulness of George and Sarah Green might have forsaken them, and their latter days have been tedious and melancholy.

Dorothy Wordsworth, Grasmere, 4 May 1808

NOTES

I ought to have mentioned that George Green's debts, save the Mortgage on his Estate, were very small and few in number. The household goods sold for their full worth, perhaps more. The Cupboard which I have mentioned was bought for four-teen shillings and sixpence; an oaken Chest for twenty-four shillings, and their only Feather Bed for three pounds. The Cow sold for but twenty-four shillings, and I be-lieve that was its full value. These articles which I have mentioned were the most valuable of their moveable possessions. We purchased the poor Woman's Churn & milking Can, for which we gave eight shillings and sixpence.

An affecting circumstance is related of Sarah Green's natural Daughter with whom she parted on the Saturday evening after having drunk tea with her Mistress. The Girl did not hear of the melancholy event till Monday Evening, and she was with difficulty kept from going herself over the Mountains, though night was coming on. In her distraction she thought that she should surely find them. I do not speak of this as denoting any extraordinary sensibility, for I believe most young persons in the like dreadful situation would have felt in the same manner – and perhaps old ones too – for the circumstance reminds me of Mary Watson, then 73 years of age, who

when her Son was drowned in the lake six years ago walked up and down upon the shore entreating that she might be suffered to go in one of the Boats, for though others could not find him, she said 'Do let me go, I am sure I can spy him! I never shall forget the agony of her face – without a tear. She looked eagerly towards the Island near the Shore of which her Son had been lost, and wringing her hands, said, while I was standing close to her, I was fifty years old when I bore him, and he never gave me sorrow till now.' The death of this young Man, William Watson, caused universal regret in the Vale of Grasmere. He was drowned on a fine summer's Sunday afternoon, having gone out in a Boat with some Companions to bathe. His Body was not found till the following morning though the spot where he had sunk was exactly known. All night boats were on the water with lights, and it was a very dismal sight from our windows. He could not swim and had got into one of the well-springs of the lake which are always very deep.

<p style="text-align:center">★ ★ ★</p>

[The following addition was made in pencil by Dorothy Wordsworth, evidently at a much later date]

The end of Mary Watson herself was more tragical than that of the young man. She was murdered a few years ago in her own Cottage by a poor Maniac, her own Son, with whom she had lived fearlessly though everyone in the vale had had apprehensions for her – the Estate at her death fell to a Grandson. He had been sent to Liverpool to learn a trade, came home a dashing fellow, spent all his property – took to dishonest practices, and is now under sentence of transportation.

The manuscript in which this text occupies 43 pages, is preserved among the collections of the Wordsworth Trust at Dove Cottage, Grasmere, with all the relevant documents – the Subscription Book, the Committee Book, the Account Books, and the receipted bills covering more than twenty years. Erest de Selincourt commented in 1936: 'together they comprise a valuable contribution to local history, and afford a model of a simple act of charity wisely conceived and scrupulously administered.'

GEORGE
AND
SARAH
GREEN

William Wordsworth

Composed 1808 – Published
September 1839

Who weeps for strangers? Many wept
For George and Sarah Green;
Wept for that pair's unhappy fate,
Whose grave may here be seen.

By night, upon these stormy fells,
Did wife and husband roam;
Six little ones at home had left,
And could not find that home.

For *any* dwelling-place of man
As vainly did they seek.
He perish'd; and a voice was heard –
The widow's lonely shriek.

Not many steps, and she was left
A body without life –
A few short steps were the chain that bound
The husband to the wife.

Now do those sternly-featured hills
Look gently on this grave;
And quiet *now* are the depths of air,
As a sea without a wave.

But deeper lies the heart of peace
In quiet more profound;
The heart of quietness is here
Within this churchyard bound.

And from all agony of mind
It keeps them safe, and far
From fear and grief, and from all need
Of sun or guiding star.

O darkness of the grave! how deep,
After that living night –
That last and dreary living one
Of sorrow and affright?

O sacred marriage-bed of death,
That keeps them side by side
In bond of peace, in bond of love,
That may not be untied!

THE GREEN HAIKUS

Written by children from Grasmere School

Lost near Langdale Fell
Darkness coming over them
Bewildered by fog.

Sarah Jackman of Easedale, aged 10

Lost on Langdale.
Frustrating winds, killer hail,
Frost Sleet, Icy fingers.

Conrad Moody of Langdale,
aged 10

Frozen toes storm howl
Frosty fingers crunching snow
Clutching cold lights die.

Sarah Jackman of Easedale,
aged 10

THOUGHTS ON THE GREENS' TRAGEDY OF MARCH 1808

Richard Hardisty

I am no more than a village person, brought up in beautiful Grasmere, and I haven't really strayed far from the valley of my upbringing.

However, part of that upbringing did involve some knowledge of the Green family and the tragedy that befell them on that fateful day, 19 March 1808. What were my thoughts? Well it always struck me as being a very sad tale, and as a small child could provoke certain anxieties if dwelt upon for too long.

The name Green was indeed familiar and often spoken of. At Grasmere school, our delicious dinners were cooked and served in the Reading Room by Mrs. Thompson, a lovely lady with a kind and ready smile for everyone. However, as was often the custom around here, married ladies could still be referred to by their maiden names. I don't know why. Mother or Dad might say 'I've been talking with Cathy Green in the village'. The name lived on and it is good to see Cathy's son James and his family here this evening and proudly keeping up their Grasmere connection.

I had known, as a youngster, that the Wordsworths were involved in helping the Green orphans and that a fund was raised and the children placed with families around Grasmere village. Other than knowing where they had lived, I had little information and I have no recollection of this piece of very local history being part of our learning at the village school. Local history did not feature at all. So what I knew must have been handed down through the family.

Some years later I picked up a copy of 'The Greens of Grasmere', Dorothy Wordsworth's Narrative of the tragedy, first published in 1936. My interest in our village history had deepened by then and this was indeed a fascinating and moving story.

Names were identified and my family supplied information about various descendants; where they were now and which ones had moved away. It was all becoming much more interesting.

Through Dorothy's narrative, the Wordsworths were appearing to me as real village people, as opposed, perhaps, to the rather romantic figures, floating around in some sort of literary ether.

They were emerging as kindly, caring villagers and it was good to know of this more ordinary side to their lives and of their humanity and their compassion. They became more attractive to me. My forebears had spoken of them, particularly William, as being well, 'different', even 'difficult' and not at all easy to communicate with.

My wife Jennifer's forebears, the Ashburners however, were near neighbours here at Town End and perhaps saw them in a different light. Peggy Ashburner and Dorothy seemed to have had a good relationship for Peggy would accommodate any overspill of visitors at Dove Cottage and let them sleep over at her cottage. I have wondered who these visitors were?

William's wife Mary, was also appearing to have had a good heart for, despite having her own children, she was actively involved on the fund raising committee and in the supervision of the fostering of the orphans.

But, of course, the whole village was involved as best it could. Everybody played their part. It is heartening to read of the search parties being organised and of all the fit and able men of the parish turning out on to the snow-clad mountains. It is suggested there may have been a party of around sixty of them, and they gathered near the church and devised a safety code of whistles for communicating. They spent days searching the fells before the bodies were discovered on 24 March.

This story brought to mind memories from my childhood when walkers went missing on the Grasmere fells in similar wintry conditions. If a walker was reported missing, the village policeman would gather up as many shepherds, farming folk and fit men from the village as he could muster and they would all turn out to look for the lost person.

My father, being a shepherd with a good knowledge of the fells and especially the Fairfield range, was usually one of the first asked and of course the sheepdogs, skilled at finding sheep buried in the snow drifts were a useful addition to the search. Some of these searches concluded happily. Others, like the Green's, resulted in loss. There was always concern when the searches continued into darkness. But it does illustrate a wonderful aspect of human nature that when there is a great danger and a great need, there are willing souls who face personal risk to reach out to help. Here in Grasmere it happened in 1808, it happened in my childhood and today, with the Mountain Rescue organisations, it continues to happen.

About 18 years ago, a Grasmere hill farm was being dismantled as a working farm. That is always sad, but especially this time for Jennifer and her father. This, an old traditional farm, had belonged to their Fleming ancestors, great uncle Isaac Fleming in fact. One parcel of land was an Intake, in Easdale of about 10 acres. It was rough fell ground and was just up behind Blindtarn Cottage, the home of the Green family. A few years earlier, Jennifer had received a small inheritance from her Grandfather and had earmarked it for something meaningful. We decided to buy back this piece of Fleming land

and retain the family connection. The intake had been neglected for around fifty years and much of its surrounding dry-stone walls were broken down and in disrepair.

Over a period of about nine years we gradually repaired the stone walls. Before you assume we were very slow wallers, I must advise that this work was done in our spare time, evenings and week-ends, and outside our normal working hours!

Each visit to the land involved walking past Blindtarn Cottage, and every time I walked by I could never avoid a dip in my feelings. There was always a slight sadness over George and Sarah Green's accident, the desperate plight of their six children. I thought of that young family who had been left anxious, waiting and wondering, in that lonely house standing in deep snow, back in 1808.

Working away at the wall gaps, perhaps three or four hundred feet above the cottage, spirits lifted and thoughts turned to the lives of the orphans, their new homes and new families and the fact that they had survived and grown up in the valley of their birth. They each lived a good life and went on to marry and have their own families. Indeed, some of the descendants are here tonight, and even more will be coming on the walk to Blindtarn Cottage tomorrow morning and then attending the gathering in Church tomorrow afternoon. It is as though descendants are returning home, to Grasmere, for an hour or two on a special day.

We worked away at the land and on hot days drank from the little cool beck that bounces down the hillside, it would also have been the Green's water supply. Our conversations often turned to them and the orphans. Some were fostered by Jennifer's forebears. The oldest and youngest daughters, Jane and Hannah were kept together and went across the valley to Winterseeds to live with the Watsons who were described as a kindly couple.

The eight years' old John Green went to live with elderly John Fleming and his wife at Tongue Gill, near Winterseeds. It seems John Fleming was concerned about George and Sarah Green's poverty and he would do what he could to help them by appropriate acts of kindness. This would be difficult, for he would realise that despite their poverty, the Greens had great pride and independence. They were good payers and owed nothing to anybody. George had inherited the house and land from his forebears and he would be desperate to hang on to it. For to lose it would have been a failure, both to his forebears and to his pride. John Fleming had given the Greens two sheep the year prior to the tragedy for he was so concerned about their welfare.

It so happens, that in 1808 John Fleming had owned 'our' intake; that enclosed piece of fell-side above Blindtarn cottage. Dorothy records that two or three months after the tragedy the boy John had apparently walked with old man John past the cottage on the fell route to this enclosure.

Young John had noticed a ewe and its lamb, a Herdwick of course, and he must have 'kenned it', dialect for recognised it, as one of his parents' flock. He had uttered words like, 'Look, me mother's yow's gitten a bonny lamb'. ('Mother's ewe has got a fine lamb'.) I find that a moving remark. For to me, it suggests that young John was coming through this terrible episode of loss, and fear, and uncertainty. My feelings are that he seemed to be looking outwards and beyond the tragedy. He was taking notice with some optimism, despite passing his old home and its associated dreadful memories. He was 'kenning' the family flock or what was left of it. It is as though there was a flicker of candle-light in his world that had been so filled with darkness. He was coming through. Helped no doubt, by the patient kindness of old John Fleming and his wife. Coming through to brighter days ahead.

The above is just one of many deeply moving episodes in Dorothy Wordsworth's narrative. But the whole story is incredibly moving and depicts Dorothy as a passionately caring person. In truth, the Wordsworth's, compared to the Greens, must have had a relatively charmed life. With help and servants and a degree of freedom. They would have no reason other than human benevolence to become so actively involved. They were, of course, employing the older Sarah Green at the time of the tragedy.

Their humanity and compassion must have been such that they could not stand back and not be involved.

I think that the tragedy of the Greens brought out in the Wordsworths, as well as all the other inhabitants of Grasmere in 1808, the real human qualities of love, kindness, compassion and care.

Dorothy wrote up her record of the Greens about a couple of months after the event. She was encouraged to do so by William who thought she ought to, 'leave behind a record of human sympathies and moral sentiments, either as they were called forth or brought to remembrance by a distressful event'.

However she resisted much pressure to have it published fearing it would, as she writes, 'bring the children forward to notice as individuals, and we know what injurious effect this might have upon them'. She did not want to upset the children's delicate feelings or bring them forth as objects of curiosity. That was thoughtful of her, and maybe as she herself had lost parents at a young age, she may have felt this deeper empathy.

Dorothy's narrative was eventually published in 1936 and in 2005 I wrote a short article on the tragedy, for Grasmere's Parish Magazine.

I realised that three years hence would be the bi-centenary of the event and perhaps it should be commemorated.

I spoke with Jeff Cowton, curator at The Wordsworth Trust and we felt this may be of interest while affording an opportunity to exhibit some of the manuscripts kept by the Trust. Our Rector at St. Oswalds, the Reverend

Cameron Butland was happy to be involved and we hoped to include the village schoolchildren.

There was a concern. Would it be entirely appropriate to recall such a sad family event, a Grasmere family's tragedy? After all there were descendants still living in the village and elsewhere and it had happened to their forebears. We should be sensitive to all their feelings. Dorothy had considered family feelings then and we should show similar respect now.

We aired our ideas and asked for any objections. There were none, in fact there was definite encouragement.

It was important to us to hold the event as a real village remembrance. The visitors would be welcome of course, but we did not want it to be promoted as a 'tourist attraction' and we certainly did not want to capitalise on it in any way whatsoever.

Enthusiastic offers of help and involvement have come in from all around the community, for which we are truly grateful. From the Wordsworth Trust, St. Oswald's Church, the owners of Blind Tarn Cottage, Grasmere villagers, descendents of the Greens and much to our delight, Grasmere Primary School. The Grasmere children now know about this piece of very local history.

If you get a chance to read Dorothy Wordsworth's narrative of the event, take the opportunity. You will not be disappointed. It is compelling and it is incredibly moving. And, of course, it happened right here, in our own village. It is very, very, much a Grasmere story.

Transcript of the talk given at the evening event in the Jerwood Centre,
Dove Cottage, 18 March 2008

THE GRASMERE NEWS

A NEAR WINTER TRAGEDY

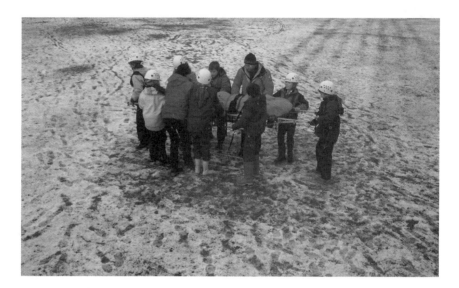

Two walkers were rescued on the 19th of March from a tragic end on Blea Rigg. The Langdale and Ambleside Mountain Rescue Team were called out by the police. They had been contacted by Jane who is the oldest daughter of the couple.

Forty Mountain Rescue Team members searched up the mountain. They used search dogs to look for the couple. A local farmer spotted Mr and Mrs Green on the summit of Blea Rigg just four hours earlier. 'I saw them on the top of the hill but I did not think they were in trouble. I just thought they were drunk because they were shouting an behaving strangely,' said Mr Hackwell, who was looking after his sheep on Blea Rigg at the time.

It was cold and a blizzard made the search hard for the Mountain Rescue Team.

Eliot Gledhill, a member of the Langdale and Ambleside Mountain Rescue Team explained 'The wind was ferocious and the visibility was terrible but Mr Green had been sensible, and had a whistle with him. This made it much easier to find the couple because we could hear them from a long way away.'

Sarah Green, mother of eight, was badly hurt and suffering from hypothermia.

The snowy weather and freezing temperatures meant we had to get Mrs Green off the hill fast. Mr Green was not hurt so he walked by the side of the stretcher, said Eliot Gledhill, a member of the rescue team.

It was a terrible journey but I'm so grateful to the brave people in the Mountain Rescue Team, they were wonderful, said Mrs Green.

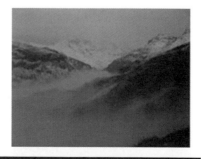

A PARABLE OF COMMUNITY

Reverend Cameron Butland

What is a community? The two hundredth anniversary of the extraordinary response of the village in 1808 to a common tragedy should give us all pause for thought. In an age of the welfare state and social services it is good to be reminded of our predecessors in Grasmere who had none of these advantages, and yet sought to care for six of their number in the gravest of need.

The story of the death of George and Sarah Green and the fate of their orphaned children touched the hearts of people two hundred years ago. The subscription book records gifts from poor and rich alike, from a few pence to significant amounts of money. The fund though is but one aspect of the community response, the actions of the village in the first few days in March 1808 speak of a closely knit village rooted in mutual respect and support. Even the desire to place the orphaned children in homes close to each other shows an extraordinary care and feeling towards these grieving children.

For those living after these events the humanity of the Green's story is of course kept alive through the vivid words of Dorothy Wordsworth's narrative. Her closely observed comments, which are often perceptive without being unnecessarily unkind, speak of honesty in reporting and an attempt to present the human story in all its depth. We are indebted to her for this parable of community life, for it speaks not just of Grasmere in 1808, if we have the wit to listen – it speaks to us also of our own times.

What is a community in 2008? Quite clearly in superficial outward ways very different from the life of our ancestors, and yet deep down do we not long for their world? A world where everyone would miss days of work to search for a neighbour in distress; a world were mothers would rush to attend the needs of the orphaned; a world where every section of the community would do everything in their power to care for children in need – this is a very attractive view of community living. Community has to be more than just a share place to dwell, it is about shared values and mutual respect, where differences are acknowledged but where the ties of togetherness are stronger.

In celebrating the two hundredth anniversary of the Green's story the present village of Grasmere has expressed a desire for community life. The experience of 2008 has spoken of the power of ideas in the form of a story to offer a parable of community. Most of all the Green's story asks us, what do we want from community living? – by their example we will look for our answer in terms of our values and hopes.

REFLECTIONS FROM DESCENDANTS

Through my mother's side, I descend from the ill-fated George & Sarah Green via, John 1800–1890, Thomas 1831–1904, James 1861–1938, Mary (Polly) 1890–1966, later Baisbrown and my mother Marjorie 1914–1990.

The sad story of George and Sarah's death and the plight of their young children in 1808 was first related to me by Grandma Polly when I was quite small; so it was with delight that I accepted the invitation to take part in the bi-centenary rememberances in Grasmere on 18th and 19th March 2008.

My own ancestral research revealed that the husbandries of Blindtarn, Brimmerhead, Guddy Bridge, Kittycrag and Under the How in the Easedale Vale had all been owned or occupied by members of the Green family from at least the sixteenth century. In my teens I walked the route from Blindtarn to Langdale and back trying to imagine the events of that fateful journey. Even now I am still drawn to at least one visit to the vale each year and become the subject of strange eerie feelings about the place and sense – 'This is my Home'.

The tragedy was well documented by Dorothy Wordsworth shortly afterwards and there is no doubt she greatly influenced the sympathies of all the villagers and united them to set about improving the future of those poor orphans. It does also make me think what the scenario might have been without her input and what I would be doing now.

Much of the huge response at the time was due to George and Sarah's history of honesty and endeavour, although limited in means. This sad story happened when Grasmere was a self-sufficient local village and such events are the bedrock of Grasmere's history and it is imperative that local events and traditions are kept and remembered. After all History is Heritage and Heritage is identity.

Alan Read

The Greens bi-centennial commemoration was a very memorable few days for my family and myself. As well as proving informative and entertaining it also provided the opportunity to renew friendships with village members that I have not had contact with for many years and make new friends.

The Tuesday evening lecture was very detailed, and provided much enlightening background and motivational information. Thanks also to Richard for his contribution that evening – it put things into today's perspective.

The walk on the Wednesday morning was a nostalgic journey and an opportunity to converse with distant relatives, not met before.

The high point of the session in the Church was, for me, the enactment by the school children. The way they threw themselves into the roles was a joy to behold. I have shed tears in church before, but on this occasion it was from pure laughter.

It was good to see so many different agents from the village involved in the activities. These sorts of events show an amazing unity and spirit. May Grasmere enjoy many more similar.

Sincere thanks to all involved in putting this together.

James Thompson

CROSS CURRICULA TEACHING

Johanna Goode

Our cross curricular theme this term has been the history of farming locally. As the Greens were local farmers, and the bicentenary of their tragedy was in the last week of term, their story arose early in our work. The children were fascinated by it, poring over local maps, visiting the places mentioned, acting out the events of Dorothy's narrative etc. This tale quickly became the main focus of our work.

The Wordsworth Trust very kindly offered us the use of part of their exhibition space, and all their staff and expertise, so that we could put on an exhibition. This was hugely motivational for the children. Everything, from choosing artefacts to the font used in labelling, had to be discussed and decided. Writing poured out of them, as the deadlines became tighter and tighter... invitations to the private view, posters for the village, explanations of artefacts, press releases, discussions with journalists etc

As we were working towards this exhibition and towards a Memorial Service to the Greens in church, the children had to think about how to bring the story alive for others. They wanted other children to imagine the scenes of 1808, and to compare them with what would happen today. According to our literacy long term planning, we were supposed to be working on plays and classic poetry this term. A play was written and recorded, to play during the exhibition. It evoked the atmosphere in the cottage, whilst the children waited for their parents. The children also made 'the cottage', with dressing up clothes, etc. Other writing organically arose, to help bring the tale to life. For example, fictional 'diaries' written by the children were put in the cottage. A modern version of the story was written as a play which the children performed in church at the Memorial Service. Dorothy Wordsworth 's narrative was our key text, providing all the evidence we required. William's poem was also studied. The children then wrote their own emotional responses, as haikus, having collected a huge bank of related powerful vocabulary and figurative language. They also used Wordsworth's poetry to look at rhythm and rhyme before embarking on song writing for the Memorial Service. Song writing is obviously great for sentence construction and careful choice of vocabulary, as the restrictions are huge!

There have been wonderful speaking and listening opportunities throughout this topic. The children had to persuade members of the Wordsworth Trust to lend certain artefacts, speeches had to be written for the Private

View and the Memorial Service, journalists were rung up, interviews were conducted with the press, and the plays were performed to public acclaim.

All aspects of the children's literacy work improved during this project. I think that the most deeply learnt lesson was that editing really does matter. For example it was wonderful to hear the children reminding each other of the agreed font size and style, and helping each other to check and re-check labels for accuracy. Even at the last practice, children were adding bits to the play to improve the evocation for the audience, and fiercely debating the worth of these additions. They really did have ownership of this project. The village looked to them to re-tell this story, and, with the help of The Wordsworth Trust in particular, they managed to do so in a very professional way.

My favourite moments came during the Private View and The Memorial Service. At the Private View children ad-libbed with great confidence, in front of a huge audience. The Memorial Service was structured so that readings by members of the community alternated with the children's contributions. You could feel the sense of relaxation by those community members who had been persuaded into reading, as they watched the children perform. The children showed how it could be done, and the adults felt 'if they can do it, well so can I'. It was a very moving occasion.

THE TRAGEDY OF THE GREENS: WHAT WOULD HAPPEN IN 2008?

A play by the children of Grasmere School

Scene 1

George	I feel better after that pint of bitter. Come on darling, let's go home.
Sarah	Which way do you think we should go?
George	Over the fells.
Sarah	Well that makes sense, because I've just seen the last bus go.
Ethan	Have you heard the weather forecast? I know they're not always right, but it looks like a blizzard's coming in.
Sarah	Was there anyone in the pub who might give us a lift?
George	No, I didn't see any locals.
Ethan	Why don't you stop over? You can have a room here if you like.
Sarah	We can't do that; we've left the children at home.
George	So long as we get back early in the morning, they won't know!
Sarah	No, come on! Let's get going. We'll get home before dark, and before the blizzard sets in.
Ethan	See you then. I'll give you a game of darts on Saturday, George!
Sarah/George	Bye!!

Scene 2

John and Jane tidying house. Other children watching telly.
Knocking at door.

Jane	John, where is Will?
John	Upstairs.
Jane	Will, answer the door, it might be Mum and Dad.
Will	Ok (opens door)
Will	Jane, it's not Mum and Dad, it's the post man.
Jane	Ok

Will says goodbye and closes door

Thomasina	Was that Mum and Dad?
Jane	No, just the postman.
Will	Wow! That wind's really loud.
Thomasina	Why aren't Mum and Dad back yet?
Jane	I know. They should have been back about an hour ago.
Thomasina	I'm scared. I wish they hadn't gone.

(noise of wind, lightning etc)

Will	What's that noise?
Jane	It's only the wind, Will.
John	Will, Jane . . . Look outside! It's snowing.
Sarah	Because of the weather, Mum and Dad must have got the bus.
John	But the last bus back was half an hour ago

(noise of baby crying . . . Jane goes to get her)

Sarah	She must need feeding. I'm ringing Mum.

(Sarah picks up phone)

Sarah	John, there's no answer . . .
Will	Maybe something bad has happened to them.
John	Yes. Maybe we should call someone.
Jane	I'll call the mountain rescue.
Thomasina	The mountain rescue!! Are they lost??
Sarah	Shshsh You'll wake Hannah. She's just dropped off again.

Scene 3

Jane	Nine . . .nine . . . nine . . .
Operator	Which service do you require?
Jane	Police please
Operator	Putting you through
Police	Hello, police here.
Jane	I need the mountain rescue.
Police	Right. Can I take a few details.
Jane	My Mum and Dad went to Langdale and said they'd be back by six o clock. It's seven now, and I think they're lost. It's getting dark and it's a blizzard.
Police	Where is Langdale?
Jane	Cumbria; near Ambleside
Police	I will contact the local mountain rescue team for you. They will want to contact you. Please can you

	give me your name, location and contact number.
Jane	Yes. I'm Jane Green, of Blindtarn Gill cottage Easedale. The phone number is 015394 35313
Police	The mountain rescue team will phone you shortly. I am activating their call out now.
Jane	Thank you. Goodbye.

Scene 4

Team leader	Oh. That's my pager . . . Couple suspected lost on Langdale fells. Search required. I'd better get straight to the base.
Leader's wife	Oh no! Oh well. Awful night for it! See you in the morning!
Team leader	(Radios Sarah) Hello Sarah. We need both deputies at the base as soon as possible. Full search needed on Langdale fells.
Sarah	OK. See you there. I'll phone Megan.
Team Leader	(and deputies at base) I've spoken to the girl on the phone. It's her parents who are lost. They're local, but they're well overdue, and not well equipped.
Sarah	Shall we send the dogs in?
Team Leader	Yes. Why don't you organise that. Megan and I will get 2 groups together, to start going up the most obvious paths.
Megan	1 up Mill Ghyll and 1 up from Blindtarn Gill.
Team Leader	I'll sort the Mill Ghyll one. Langdale and Ambleside Mountain Rescue base calling all LAMRT members. Full search. Please come to base. Confirm if available.
Matthew	Matthew to base. Coming in now. Over
Jack	Jack to base. Coming in now. Over.
Elizabeth	Elizabeth to base. Coming in now. Over.
Henry	Henry to base. Coming in now. Over.
Rebecca	Rebecca to base. Coming in now. Over.

All team members go to back of church. Mountain rescue group put on bags etc. One group with siren 'drive' to back of Langdale aisle. Then both groups start moving from back of church as if windy. Freeze.

Scene 5

Sarah	Let's find a shelter. It's getting darker by the minute.
George	Shall we phone mountain rescue?

Sarah	Yes. Ow my fingers are so cold. Oh no! I've dropped the phone. I can't find it. George, have you got a torch?
George	No. Nor a whistle. That was stupid of us. Next time we'll bring one. And a whistle.
Sarah	If there is a next time. I'm freezing.
George	What are you doing?
Sarah	Trying to find the . . . Aaaaaaargh. *(Falls down pulpit stairs)*
George	Sarah? Sarah? Sarah?
Sarah	Euuh . . . George . . . help . . .
George	Finds Sarah Don't worry Sarah. Someone will come and find us. I'll keep you warm.

Scene 6

Megan, Matthew,

Rebecca	*Starting from back of church going up different aisles*
Megan	Go and find, Fred. Go find.
Henry	I'm so cold
Matthew	It's disgusting out here. I hope we get through all right.
Elizabeth	I'll have the torch first
Henry	Go and find Milo. Go find.
Sarah	Why have I got the heaviest pack again????
Elizabeth	Mine's heavier
Rebecca	Watch out for this drift. This blizzard's getting worse!
Fred	Barks and runs back and forwards between Megan and Sarah/ George
George	Thank goodness you've found us. Sarah's hurt.
Matthew	I'll get the stretcher out.
Rebecca	Here you are Sarah.
Megan	Radioing Sarah's team.....
George	Is she going to be ok?
Elizabeth	Yes. But it's just as well your daughter phoned us. Two more hours, and you wouldn't have stood a chance.
Jack B	So we reckon, if this happened today. They would probably survive.